Art School

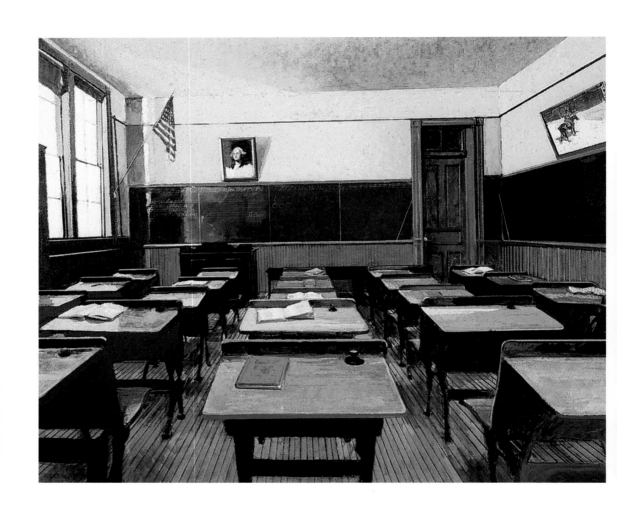

SCHOOLROOM

Art School

by George Deem

Paintings by George Deem
Introduction by Irene McManus

Thames & Hudson

This revised format edition published in 2005 in the United States of America
by Thames & Hudson Inc., 500 Fifth Avenue, New York, New York 10110

thamesandhudsonusa.com

Library of Congress Catalog Card Number 2005900860

ISBN-13: 978-0-500-51241-8
ISBN-10: 0-500-51241-8

Printed and bound in Singapore by C.S. Graphics

Contents

Introduction

GEORGE DEEM was born in Vincennes, Indiana, in 1932, the first-born of a pair of identical twin brothers. John, George's twin brother, died of measles and rheumatic fever when the twins were five years old. "I withdrew into myself," recalls Deem, "but I don't remember my childhood as a sad time. I had a wonderful childhood growing up on my family's farm in Indiana." The lost twin brother, however, may re-appear in the theme of twinning that is a prominent feature of Deem's work. And, of course, haunting absences are bound to present themselves in an art that quotes familiar great paintings.

School of Thought (p. 64) may evoke Magritte, but Deem says that it is pure autobiography. "I was making a painting of a plain Indiana schoolroom and suddenly the sky came in, and I made up these clouds, this school of thought or dreams. That is *me*, in my school-room. I can even tell you where I sat. It was in this schoolroom that poetry, magic, sex—everything—developed in this quiet and inex-pressible way."

It is equally clear that in all of his art-quoting paintings—besides passages of "art-within-art" such as mirrors, paintings, doorways,

and windows—Deem is fascinated by serial structures and by a kind of twinning in his collage-like juxtapositions.

Vermeer, Deem's favorite painter, was the inspiration for the *School of . . .* series. In the sixties and seventies Deem had been quoting and rearranging masterpieces, replicating not only image, but also style and technique, painstakingly observed at museums and in good art books—art books with a lot of technical information. Enthralled by the Dutch master, Deem spent seven years creating a body of sparkling new Vermeers, sometimes wittily juxtaposing that painter with other artists, as in *Italian Vermeer (Caravaggio),* where Vermeer's placid domestic interior seems to have been struck by some kind of Latin vendetta. In 1984, Deem on a visit to a museum observed the attribution of a painting to "School of Vermeer." That gave him the idea of re-inventing his Indiana schoolroom as a Vermeer art class (p. 20): a drawing fallen on the floor is a student sketch of the *Maidservant Pouring Milk,* the life-drawing model posed at the front of the classroom (Deem's earliest repeat pairing in the *School of . . .* series), while *The Girl with a Red Hat* is featured up front on a student's desk—perhaps Deem's *own* desk.

Deem's fraternal identification with Vermeer goes deep. Vermeer, who died in 1675, was born in Delft in 1632—precisely three hundred years before Deem, who on one occasion celebrated his own birthday with a visit to Delft. Vermeer appears to have acquired for Deem a twin-like "mirror-identity," something Deem may seek in many of the artists who attract his eye. He owns to having sometimes been unnerved by his mediumistic skill in replicating the work of other artists. "It was a frightening revelation to me that I could

paint a Matisse. I don't like using so much color. But Matisse taught me to relax—to just do it, not work up to it." In Deem's Matisse venture, one artwork by the master appears in two canvases: *School of Matisse 2* (p. 51) liberates the figures from Matisse's *Dance,* present as a simple student sketch in *School of Matisse 1* (p. 50). *School of Matisse 2* , where Deem out-decorates the master, is one of the most ravishing and witty paintings in this book.

Each of the artists quoted by Deem has taught him something— the series of *School of . . .* paintings is really an art school, with Deem acting as both student and teacher. Ingres, for instance, taught Deem to: "draw it first—he knows the first stroke is *it.*" In Deem's sumptu-ously Napoleonic *School of Ingres* (p. 33) hung all round with the works of the master (skillfully rendered in perspective), Deem proposes that the model for today's life-drawing class is (who else?) the lush bather of Valpinçon, perched on a desk during class recess and chatting amiably with Oedipus, the model from next door. Standing at the blackboard, instructing the class on how to draw the bather, is the dashing young Ingres of a self-portrait. The exquisite Comtesse D'Haussonville stands pertly by, plainly unimpressed by the life-drawing class turned lolling harem at the far end of the schoolroom, where we glimpse some of the twenty-three bodies the aging Ingres sardined into his *Turkish Bath*—including the distant diminutive twin of the Valpinçon bather, recycled by Ingres as a man-dolin player at the bath.

For *School of Hopper* (p. 54) Deem envisaged "Depression-era lessons like crime and prostitution, in an art school for adults who can only meet on Sunday mornings." Hence the painting *Early*

Sunday Morning displayed on an easel at the front of the classroom, a canvas that mirrors the view through the window behind the *Nighthawks* diners, who are Deem's class instructors. The slatternly nude from *Eleven A.M.* amusingly fixes the exact time of day for us.

The schoolmistress in Deem's masterly conceived *School of Balthus* (p. 55) is the Vicomtesse de Noailles, an elegant patron of the arts who also happened to be a descendant of the Marquis de Sade—a significant family connection considering the playful eroticism of Deem's Balthus-reverie. In the Balthus painting *Thérèse Dreaming* the young model bends both legs at the knee. In Deem, Thérèse's right knee stretches across the desk in an attitude mimicking the luxurious self-abandonment of the voluptuous young nude of *The Room* exposed to the light by her sinister dwarf attendant. Deem sets up a series of suggestive twinnings: between the boy in his school smock and the card-playing girl facing each other with one foot on the ground, one knee on a chair; between the two girls on all fours, rumps in the air; and between the two girls who are nude—one in an amorous swoon, balanced by the other apparently more wholesome, less exposed nude in stately Egyptian profile. A hidden pair of twins (one wholesome, one absolutely not) perhaps lurks in Deem's inclusion in his painting of the workman in white from *The Street*, since one reading of that Balthus painting interprets the workman as Lewis Carroll's carpenter from *Through the Looking Glass* crossing the street between Tweedledum and Tweedledee—Tweedledee too lost in a daydream to notice that his dark twin Tweedledum is molesting Alice.

In quoting Chardin's great painting *The Governess*, Deem removes

the eponymous leading player: the shamefaced schoolboy lowers his gaze, but no recriminating governess confronts him. In art quotation, or juxtaposition (Deem has referred to himself as a "juxtapositionist"), the choice to omit certain key figures from famous paintings becomes a dramatic device, compelling the spectator to ponder the artist's choices. But again, the *School of Chardin* (p. 27) has its element of twinning: in the lower left, the young draftsman appears in the painting of that name; in the upper right, the same young draftsman, magically sprung from his art-historical context, still raptly sharpens his black crayon in its twin crayon-holder. Thickening the plot, the *Soap-Bubbles* boy blows an affectionate raspberry at Chardin's moral message of the transience and uncertainty of life, leaning cheekily *into* the schoolroom to pop his giant bubble (making inversion yet another lively choice in the theater of the juxtapositionist).

The deceptively twinned upper and lower halves of Deem's dazzling *School of Winslow Homer* (p. 39) juxtapose differing versions of Homer's nostalgically remembered schoolroom. Deem's illusionistic "actual" schoolroom quotes *Country School* (1871) while his desk sketch loosely quotes *New England Country School*—which Homer painted a year or two later, leaving out a few of the children. Deem goes a step further, making the schoolmistress disappear as he made Chardin's governess disappear. This painting is one of Deem's most effective and exciting explorations of the schoolroom theme. His mirroring of the room in a monochromatic sketch is brilliant—turning the drawing on the desk into a still, dark pool of reflective memory. The room itself has assumed a mirror-identity. The van-

ished children and schoolmistress in the twinned room sharpen our awareness of Homer's formal play of symmetry and asymmetry in the original paintings—as well as perhaps poignantly touching upon Deem's personal loss in his kindergarten year. Most vitally of all, Deem has transposed himself into this country schoolroom of Homer's—since he is the unseen student whose hand has, *in all truth,* produced the sketch on the solitary desk.

Irene McManus

The Plates

SCHOOL OF ATHENS

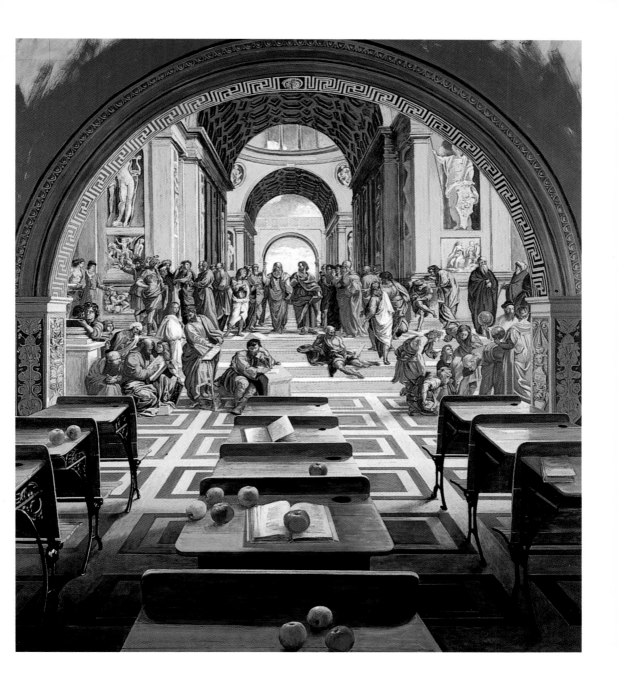

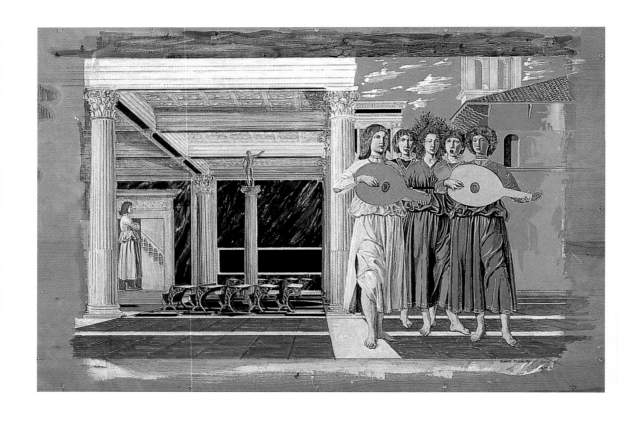

SCHOOL OF PIERO DELLA FRANCESCA

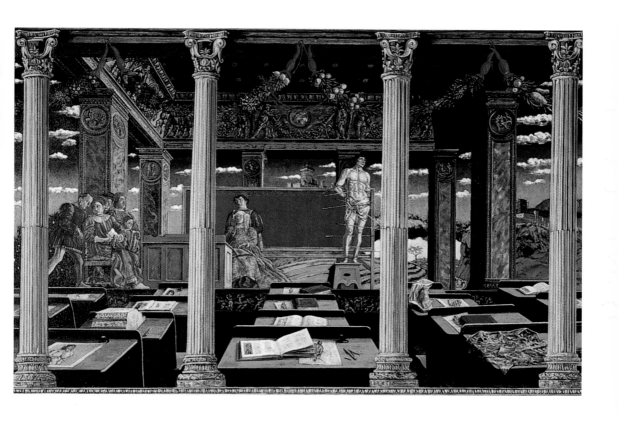

SCHOOL OF MANTEGNA

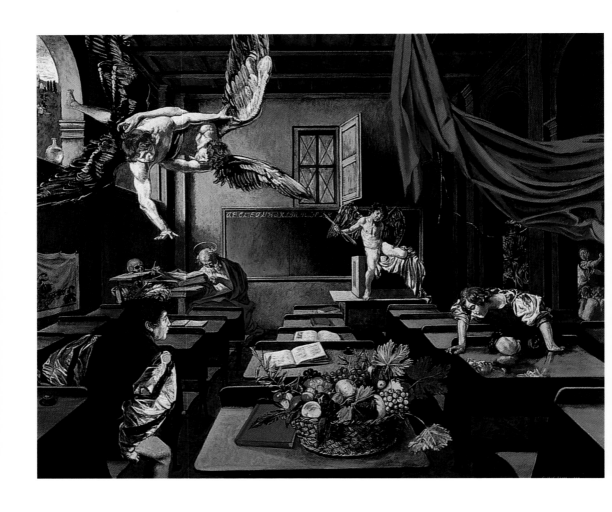

SCHOOL OF CARAVAGGIO (above)

SCHOOL OF VERONESE (opposite)

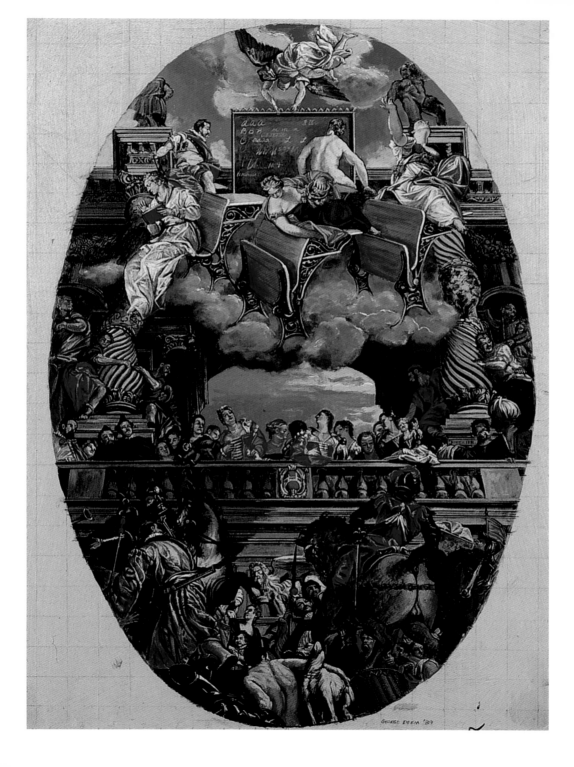

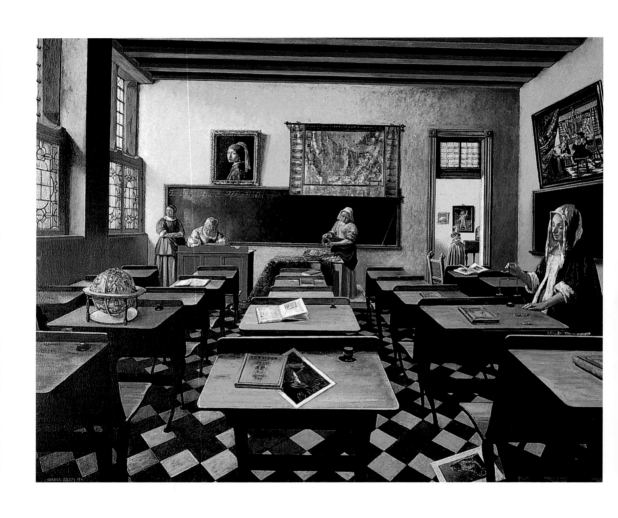

SCHOOL OF VERMEER

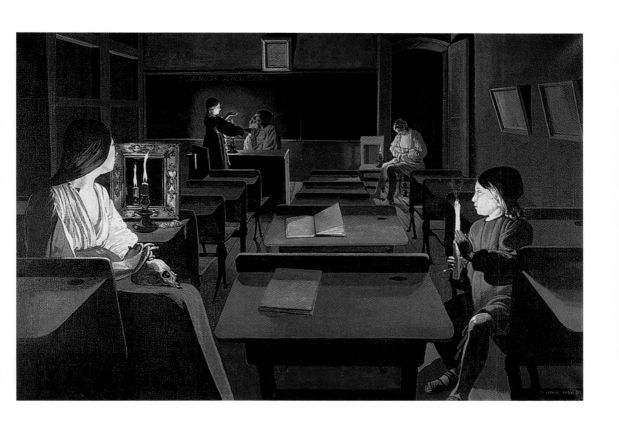

SCHOOL OF GEORGES DE LA TOUR

SCHOOL OF VELAZQUEZ

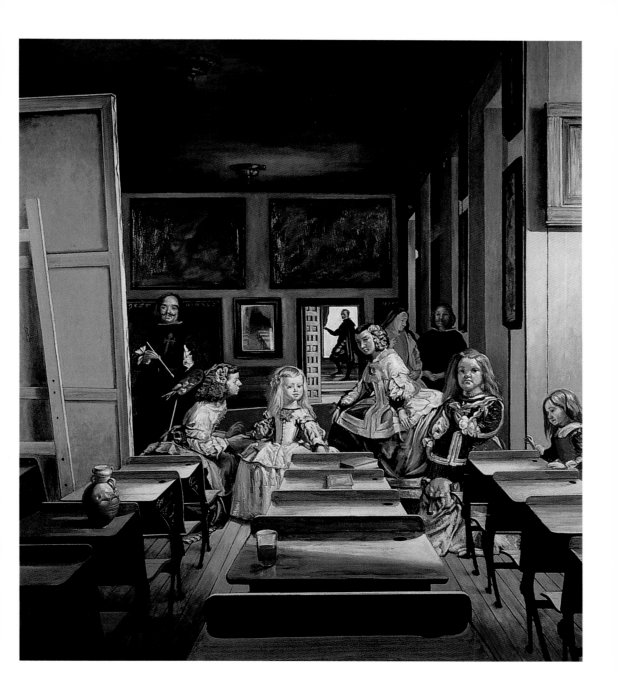

SCHOOL OF REMBRANDT

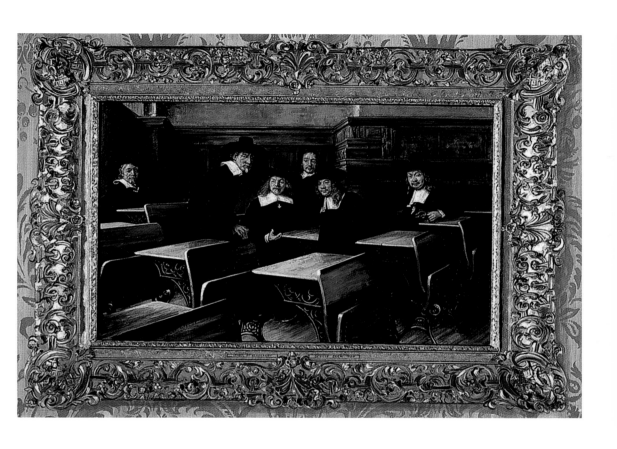

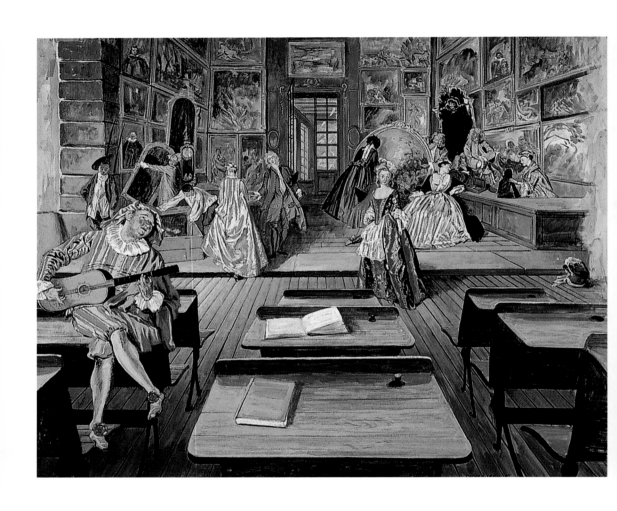

SCHOOL OF WATTEAU

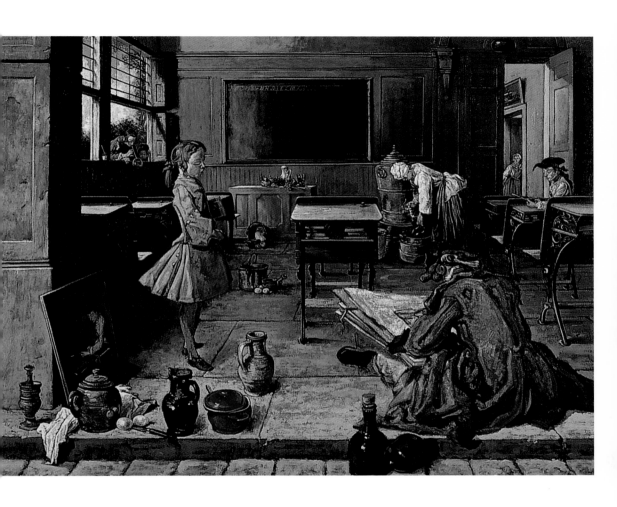

SCHOOL OF CHARDIN

SCHOOL OF CANALETTO 1

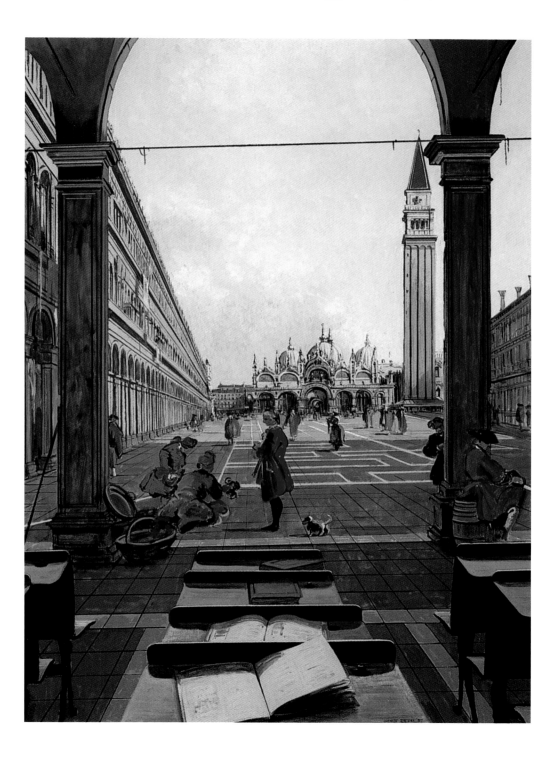

SCHOOL OF CANALETTO 2

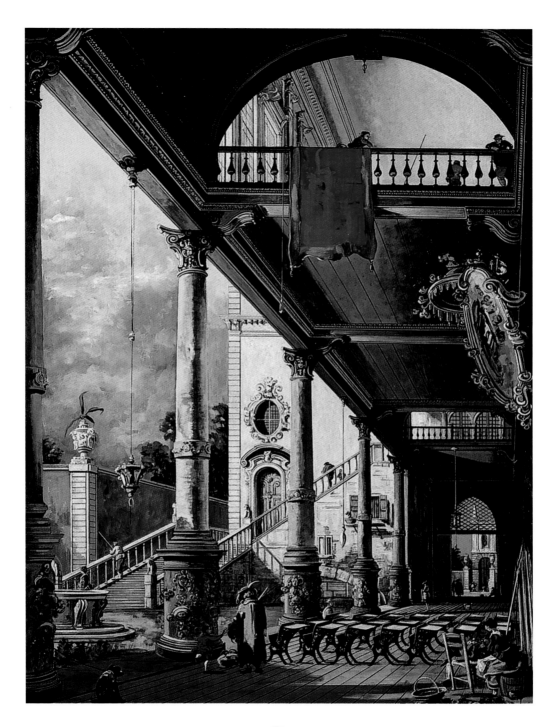

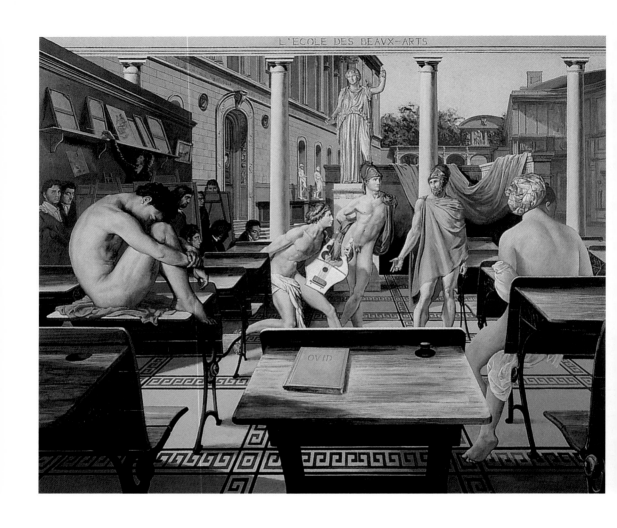

L'ECOLE DES BEAUX-ARTS

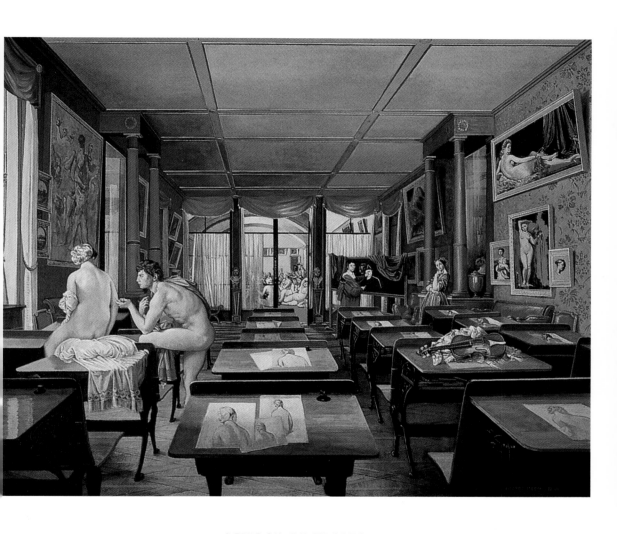

SCHOOL OF INGRES

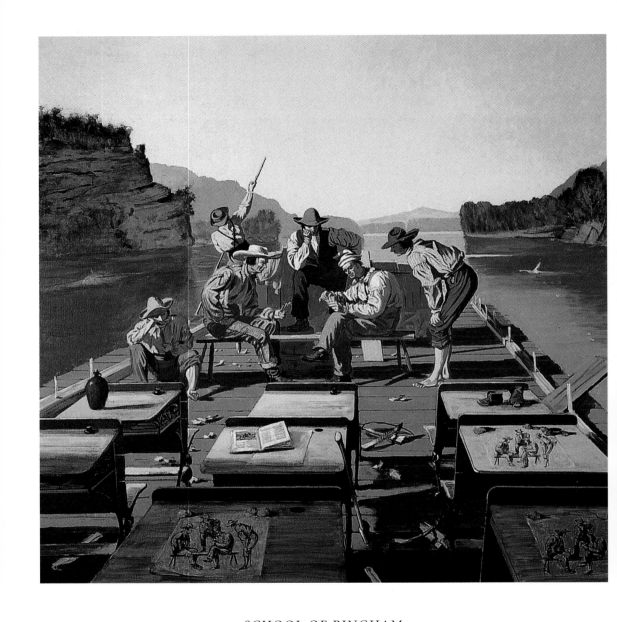

SCHOOL OF BINGHAM

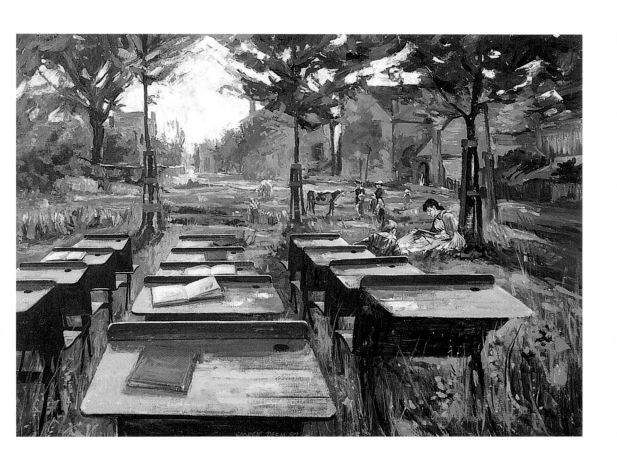

HOOSIER SCHOOL

HUDSON RIVER SCHOOL

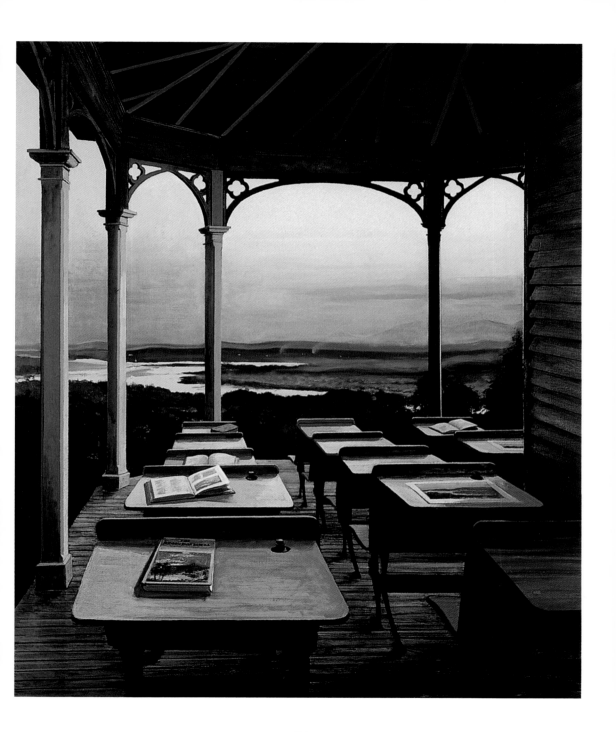

SCHOOL OF WINSLOW HOMER

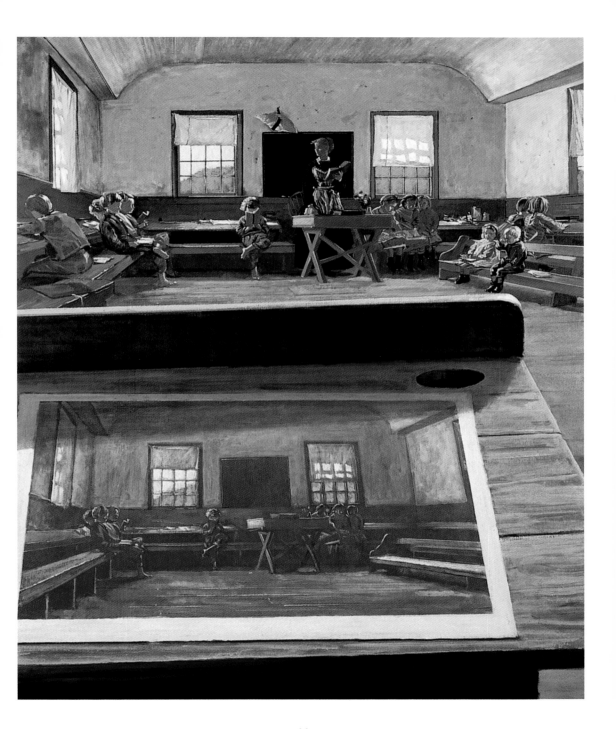

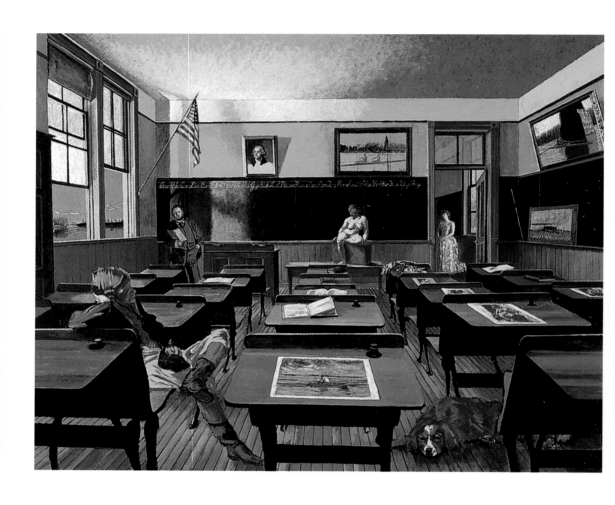

SCHOOL OF EAKINS

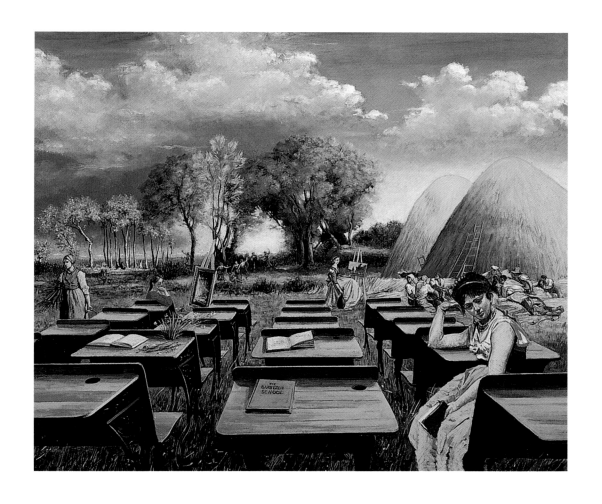

BARBIZON SCHOOL

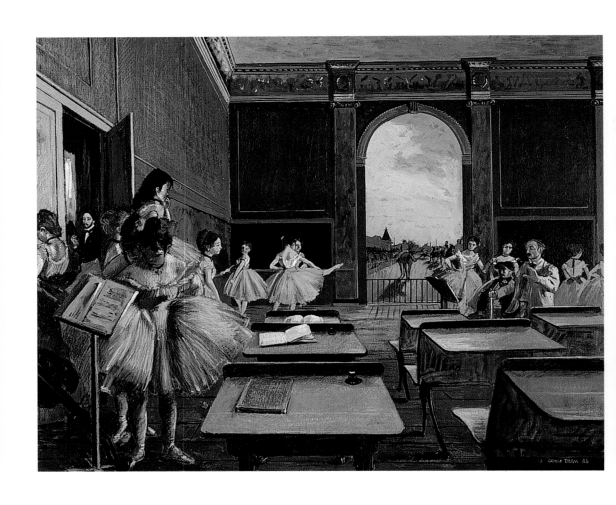

SCHOOL OF DEGAS (above)

SCHOOL OF SARGENT (opposite)

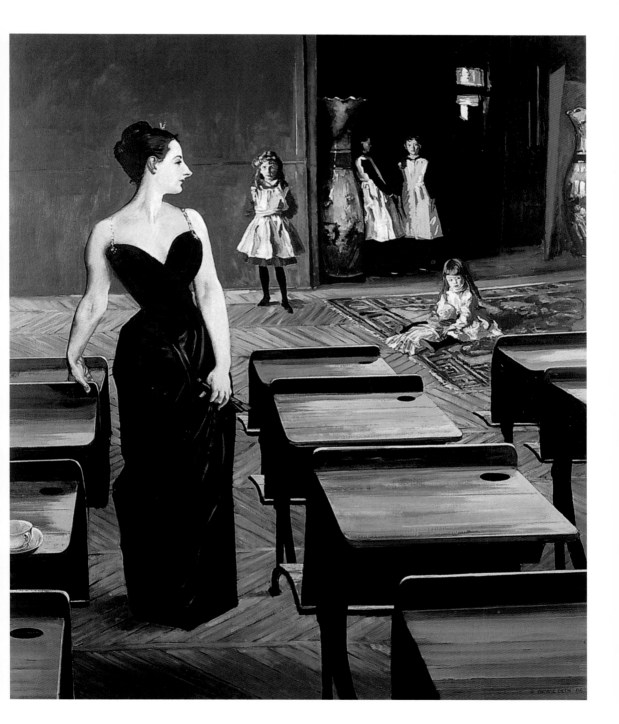

ASHCAN SCHOOL

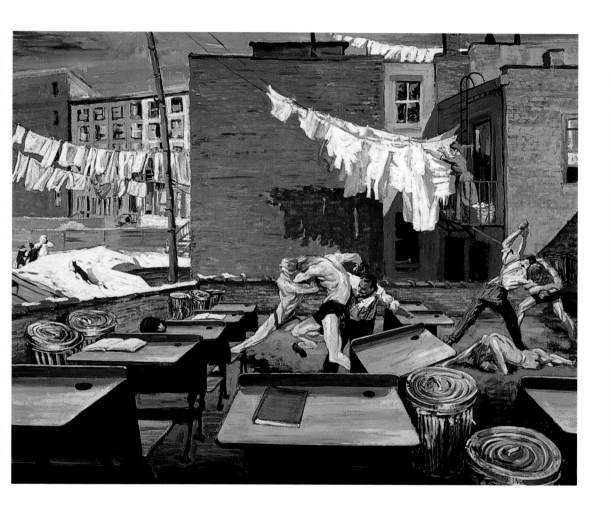

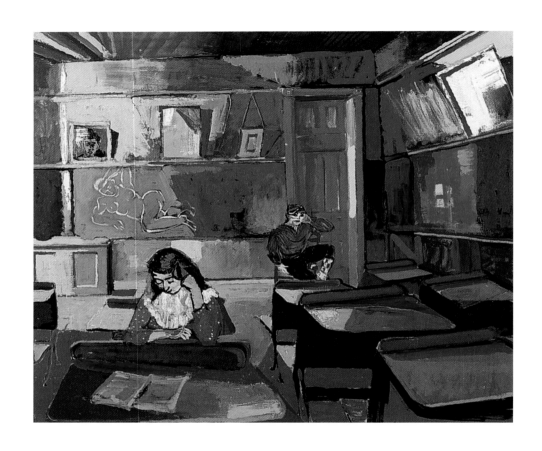

THE FAUVE SCHOOL

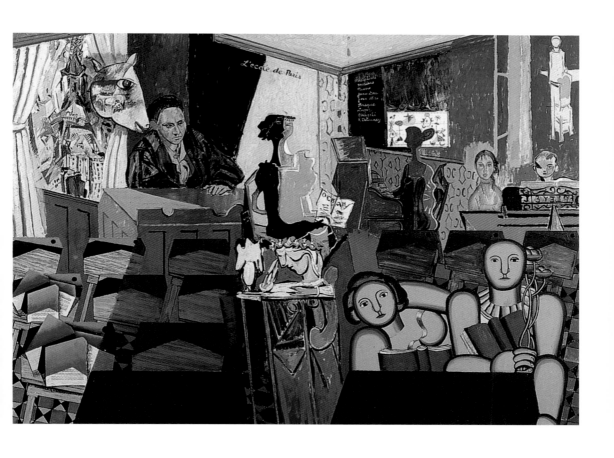

L'ECOLE DE PARIS

SCHOOL OF JUAN GRIS

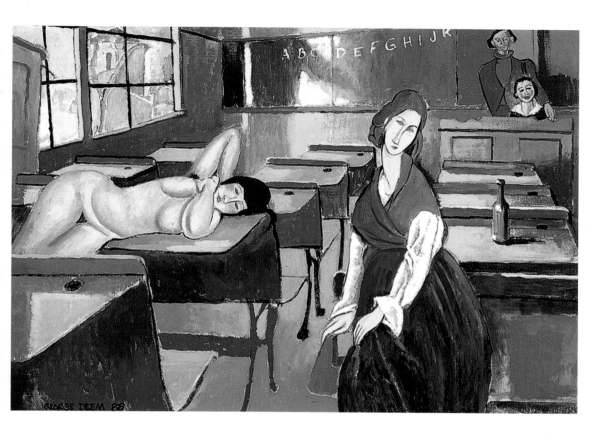

SCHOOL OF MODIGLIANI

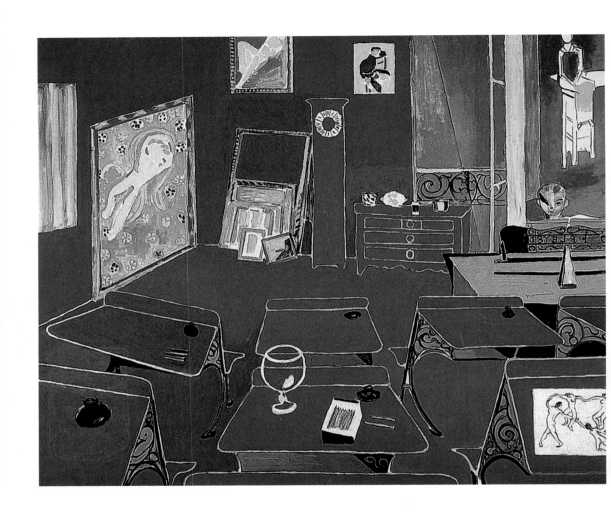

SCHOOL OF MATISSE 1

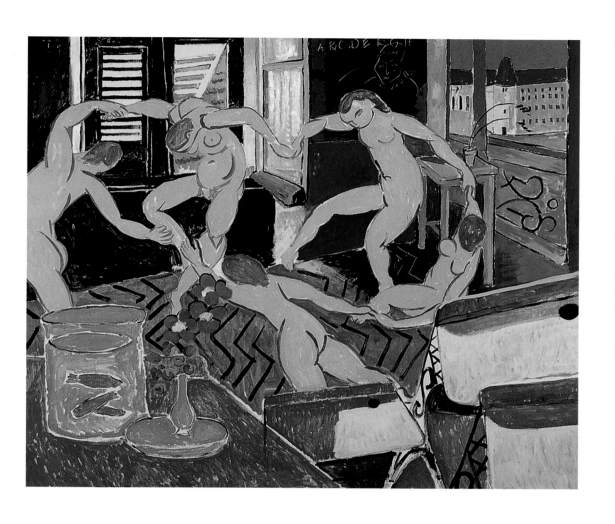

SCHOOL OF MATISSE 2

SCHOOL OF DE CHIRICO

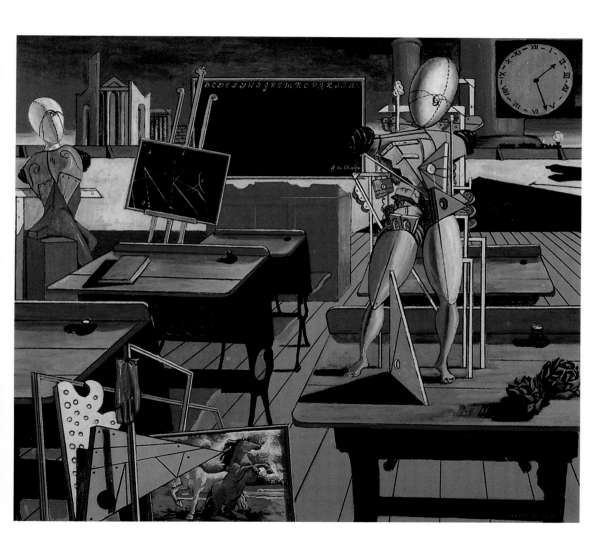

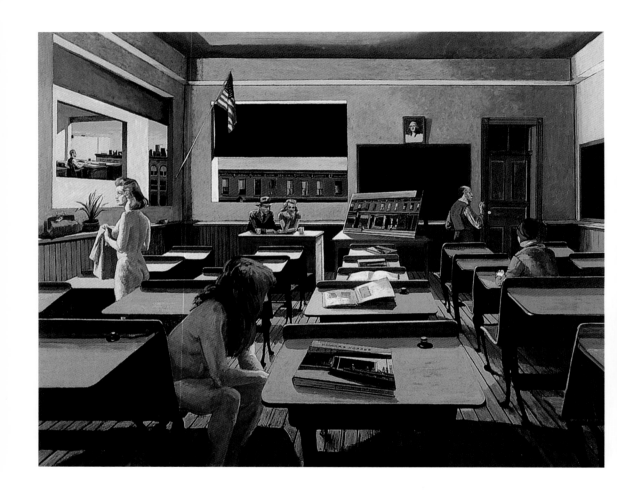

SCHOOL OF HOPPER

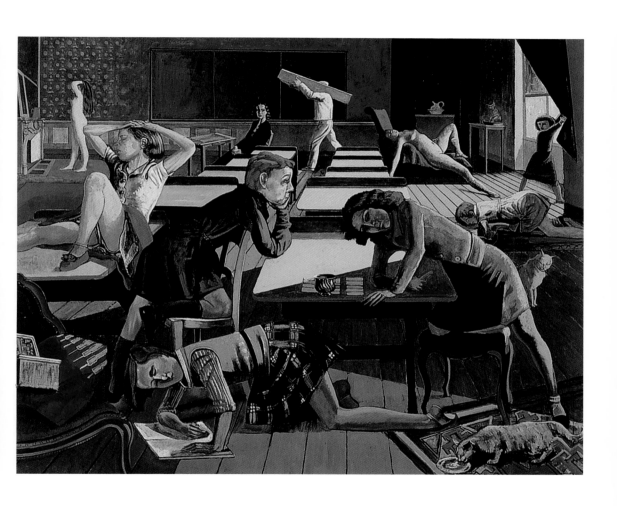

SCHOOL OF BALTHUS

SCHOOL OF STUART DAVIS

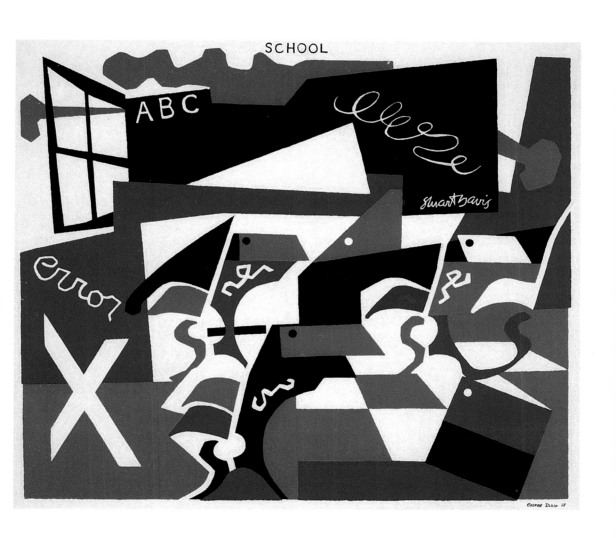

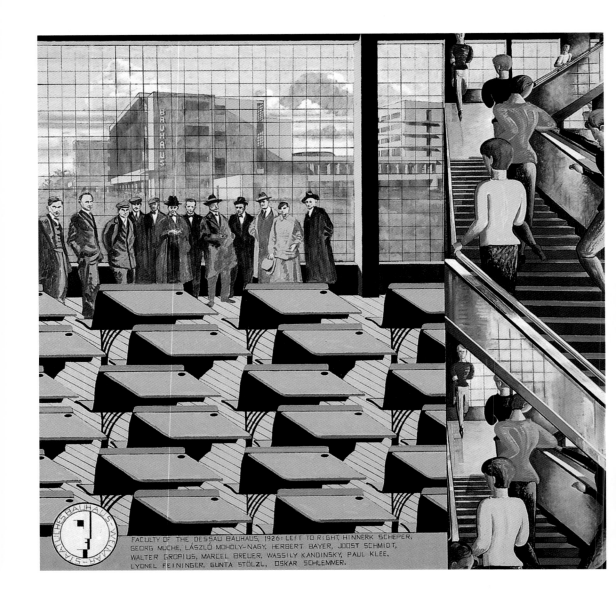

FACULTY OF THE DESSAU BAUHAUS, 1926: LEFT TO RIGHT, HINNERK SCHEPER,
GEORG MUCHE, LÁSZLÓ MOHOLY-NAGY, HERBERT BAYER, JOOST SCHMIDT,
WALTER GROPIUS, MARCEL BREUER, WASSILY KANDINSKY, PAUL KLEE,
LYONEL FEININGER, GUNTA STÖLZL, OSKAR SCHLEMMER.

BAUHAUS SCHOOL

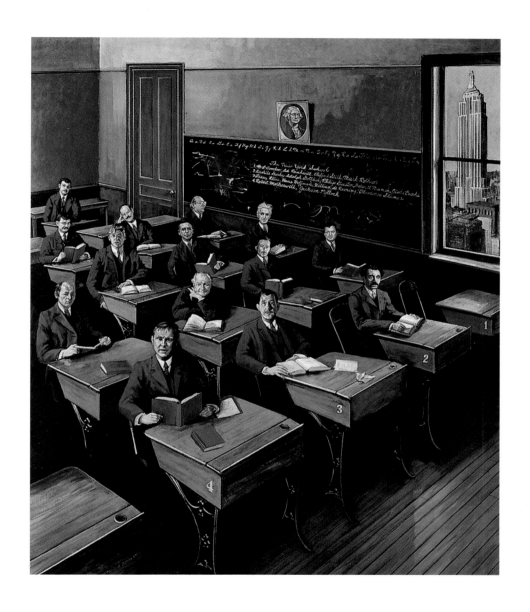

THE NEW YORK SCHOOL

List of Plates

Measurements are given in inches and centimeters, height x width

Page 2: *Schoolroom,* 1979
Oil on canvas, 34 x 42 (86 x 107)
Collection Dr. Meg Blair, Nantucket, Massachusetts

Page 15: *School of Athens,* 1987
Oil on canvas, 74 x 66 (188 x 168)
Frost Art Museum, Florida International University, Miami

Page 16: *School of Piero della Francesca,* 1988
Acrylic on wood panel, 32 x 48 (81 x 122)
Pavel Zoubok Gallery, New York

Page 17: *School of Mantegna,* 1985
Oil on canvas, 34 x 50 (86 x 127)
Estate of Phil Desind, Bethesda, Maryland

Page 18: *School of Caravaggio,* 1984
Oil on canvas, 34 x 42 (86 x 107)
Collection Garland and Suzanne Marshall, Clayton, Missouri

Page 19: *School of Veronese,* 1989
Oil on canvas, 40 x 30 (102 x 76)
MGM Grand/Mirage Resorts, Inc., Beau Rivage Hotel, Biloxi, Mississippi

Page 20: *School of Vermeer,* 1985
Oil on canvas, 34 x 42 (86 x 107)
Collection Garland and Suzanne Marshall, Clayton, Missouri

Page 21: *School of Georges de La Tour,* 1986
Oil on canvas, 34 x 48 (86 x 122)
Collection Mrs. John P. Robertson, Evansville, Indiana

Page 23: *School of Velazquez,* 1987
Oil on canvas, 70 x 60 (178 x 152)
Private Collection

Page 25: *School of Rembrandt,* 1989
Oil on canvas, 30 x 42 (76 x 107)
Albrecht-Kemper Museum of Art, St. Joseph, Missouri, W. Dean Eckert Bequest

Page 26: *School of Watteau,* 1987
Oil on canvas, 32 x 39 (81 x 99)
Collection Mark and Liz Williams, New York

Page 27: *School of Chardin,* 1985
Oil on canvas, 40 x 50 (102 x 127)
University Art Museum, Arizona State University, Tempe, Arizona

Page 29: *School of Canaletto 1*, 1987
Oil on canvas, 42 x 30 (107 x 76)
Collection Mr. and Mrs. Mark Holeman,
Indianapolis, Indiana

Page 31: *School of Canaletto 2*, 1987
Oil on canvas, 50 x 36 (127 x 91)
Collection Tina Ing Yahng,
Kentfield, California

Page 32: *L'Ecole des Beaux-Arts*, 1991
Oil on canvas, 58 x 70 (147 x 178)
Collection George Freedman, Sydney,
Australia

Page 33: *School of Ingres*, 1985
Oil on canvas, 40 x 50 (102 x 127)
Becton-Dickinson & Company,
Franklin Lakes, New Jersey

Page 34: *School of Bingham*, 1985
Oil on canvas, 34 x 34 (86 x 86)
Hallmark Fine Art Collection,
Hallmark Cards, Inc., Kansas City,
Missouri

Page 35: *Hoosier School*, 1987
Oil on canvas, 24 x 32 (61 x 81)
Collection Mrs. Guthrie May, Evansville,
Indiana

Page 37: *Hudson River School*, 1985
Oil on canvas, 48 x 40 (122 x 102)
Collection Mr. and Mrs. Alan Thompson,
New York

Page 39: *School of Winslow Homer*, 1986
Oil on canvas, 39 x 42 (99 x 107)
Private Collection, New York

Page 40: *School of Eakins*, 1984
Oil on canvas, 34 x 42 (86 x 107)
Collection Chana Ben-Dov, Los Angeles,
California

Page 41: *Barbizon School*, 1986
Oil on canvas, 36 x 42 (91 x 107)
Private Collection

Page 42: *School of Degas*, 1986
Oil on canvas, 34 x 42 (86 x 107)
Collection Charles Hirschhorn,
Los Angeles, California

Page 43: *School of Sargent*, 1986
Oil on canvas, 60 x 50 (152 x 127)
Collection Mr. and Mrs. George Sarner,
Stamford, Connecticut

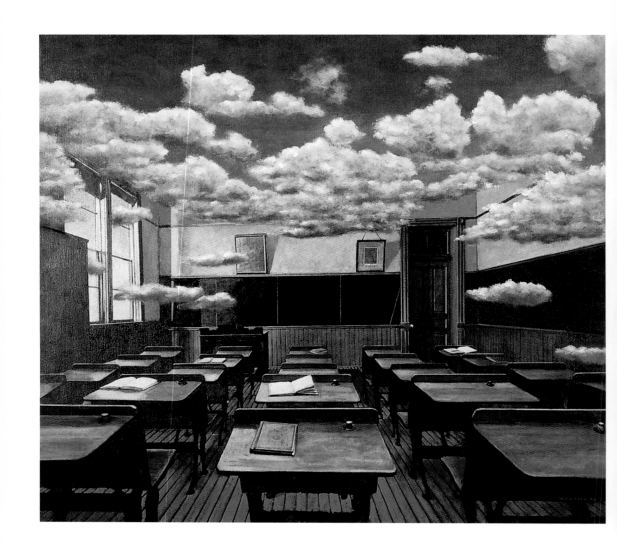

SCHOOL OF THOUGHT